Illustrations from the Inside

Illustrations from the Inside: The Beat Within
by Louis E.V. Nevaer
© 2007 by The Beat Within

All photographs © Joseph Rodriguez
Foreword © Adam Mansbach
Afterword © Jeff Adachi

Design/Production: Eliane Lazzaris & Christopher D Salyers
Editing: Buzz Poole

Typefaces used: Alte Haas Grotesk and Thurston

Library of Congress Control # 2007930508

Printed and bound by the National Press, Hashemite Kingdom of Jordan

10 9 8 7 6 5 4 3 2 1 First edition

This edition © 2007
Mark Batty Publisher
36 West 37th Street, Penthouse
New York, NY 10018

www.markbattypublisher.com

ISBN-10: 0-9790486-4-8
ISBN-13: 978-9790486-4-7

Distributed outside North America by:
Thames & Hudson Ltd
181A High Holborn
London WC1V 7QX
United Kingdom
Tel: 00 44 20 7845 5000
Fax: 00 44 20 7845 5055
www.thameshudson.co.uk

Illustrations from the Inside

THE BEAT WITHIN

Mark Batty Publisher, New York

This book is dedicated to all the young men and women who are striving to overcome the obstacles they've encountered in their lives.

And to Counselors who care throughout the nation.

A neatly-made bed, an expected sight at the facility. B-8 maximum Security Unit, San Jose Juvenile Hall. San Jose, California, 1999.

THROUGH THE DOPE GAME
AND QUICK COME-UP TACTICS
COLLECTING 100% PROPHET
everytime THE GAT click
WHEN ALL OF A SUDDEN
I STEPPED INTO THE AREN
WITH KARMA AND GOT M
ASS KICKED SOMETHING TRA
UNDERWENT A FLIPPING OF
THE S T
AND Y HEART AND
SOUL MYSELF A
G

Lance writes poetry at the Pacific New Service. When Lance first arrived in San Andreas from San Francisco, he stopped in his mother's backyard and smelled the country fresh air. One project largely responsible for his and many others' rehabilitation is The Beat Within workshop, sponsored by the Pacific News Service. This project was created in 1995 by David Inocencio, a social worker for San Francisco Juvenile Hall. He approached Sandy Close, who runs the Pacific News Service, and they decided to implement the program. The news service reaches out to the San Jose, San Francisco, Santa Cruz and Sacramento areas' juvenile hall facilities and ranch facilities. It teaches writing to those incarcerated minors. It publishes a weekly magazine and all its articles are written by minors in the system. Sometimes they give jobs to some promising writers, once they've completed their sentences. The workshops are also facilitated by kids once on the other side. San Francisco, California, 1999.

CONTENTS

FOREWORD
ADAM MANSBACH

Perhaps, under the best of circumstances, life may imitate art. But it is in the midst of life's most inimitable hardships, when the freedom to forge a bridge between experience and imagination has been taken away, that the act of creation assumes its most crucial role. In these dark and trembling moments, art is the match we strike to illuminate the blackness, so that we may remember, or discover, who we are. It is meditation; it is discipline. It renders time irrelevant, at least for a while. We create to compose ourselves, in all senses of the word.

For the incarcerated young people represented in this book, this process of composition is both utterly solitary, and marvelously collective. Their work, in all its variation—its complexity and simplicity, its hope and despair, its ancient icons and earnest neologisms, its broad cultural signifiers and intensely personal quirks—moves through the world in ways that its authors cannot. These drawings, made with nothing more sophisticated than pencils and paper, circulate among friends, acquaintances and strangers situated three thousand miles east or west, whose lives are strikingly similar to the creators'. A dialogue materializes, through words and images. Peers admire one another's work; styles are refined and reconsidered accordingly; relationships evolve between artists. And, just as importantly, between artists and the notion that artists are what they are.

In considering the dynamic fostered by The Beat Within, I cannot help but reflect upon the similarities and points of rupture between it and the graffiti movement that sprang up in a decimated New York City in the early 1970s. There, too—amidst the arson-charred buildings of the Bronx, at a historical juncture characterized by governmental neglect and underfunded schools and a cynical, racist lack of expectations about the futures possible for young people of color—a generation of artists marginalized and criminalized by uncaring institutions found a way to dialogue among themselves. They seized upon the subway

trains of the city, inscribing names and later painting murals that would travel the length and breadth of the five boroughs, turning the transit system into a moving art gallery; the forever-rotating exhibits allowed writers—as they called themselves—to remain stationary and yet watch their work move freely through the world.

Style, scale and conception evolved at exponential rates, as a confederacy of competing artists scattered across the city strove to outdo each other. Perhaps more significantly, the violent tribalism of New York's gang culture began to dissolve as writers—alongside other hip-hop pioneers and partygoers—began to understand that the provincialism of territorial posturing prevented them from fully participating in the artistic life they were inventing for themselves. The thrills of self-expression trumped the limits of a truncated world—limits both enforced and self-imposed.

I see the same impulse toward community here in *Illustrations from the Inside:* the same panoptic array of innocence and sophistication, the same democracy. Accomplished artists share physical space with neophytes; an array of styles and sentiments coexist comfortably—not because of aesthetic compatibility, but for much deeper reasons.

But graffiti was, and is, defined by the representation of the writer's name. Whether hastily scrawled or rendered elaborately in rainbow colors, the simple *I-am-here* assertion dominated, with all the politics of representation and unchecked ego the choice implies.

The artists of The Beat Within show no such predeliction, despite the facelessness that is synonymous with incarceration. Their work draws instead on mythology, glories in the heroic. It pulses with a brave and relentless narrative drive, a desire to tell a story. Seldom is the glorified self depicted, but rather the outside world that the artists have been denied, or the self in crisis, in penitence, in somber reflection. These young artists invoke courage in the form of Aztec warriors and Native American elders. They navigate the labyrinth of masked emotion by taking up the image of the crying clown, a prominent symbol in Chicano art. They are instinctually multi-disciplinary, blending words with images, statements with illustrations. Desire manifests through loving portraits of beautiful women; the distance to the outside world is lessened through the recreation of familiar cartoon characters. Connections to the fast-moving stream of popular culture are maintained through drawings incorporating the latest slang, hairstyles, and dances. For some of these contributors, a basic need to convey a feeling or sketch out a scene is all that matters; others grapple with the entanglements and dualities of life by creating incredibly intricate imagery: faces emerge from wisps of curling smoke, symbols and human forms weave together in tattoo-like tapestries of meaning.

Perhaps more than anything, the raw honesty of youth dominates these images. These artists meditate on freedom and confinement, absence and perserverance. They incorporate mantras of affirmation, toy with the imagery of death and desolation. Angels and demons grapple for the artists' souls on some of these pages—but no less real, no less heartfelt, are the drawings of Garfield and Homer Simpson, evocations of totems from a life beyond reach.

As you peruse these images, consider the power of art to forge community, the way the energy generated by a creative impulse

diffuses into the world and catalyzes another. Think about the truths contained within these pieces: the reflections on mistakes of the past, the testimonials to an arduous present, and the dreams of a better future. Think about the sustenance these drawings have both provided and inspired, and allow yourself to listen to what these artists are telling you. Become part of the conversation these young people—against all odds—are so intent on having.

Adam Mansbach's novels include *Angry Black White Boy* (Crown, 2005) and *The End of The Jews* (Spiegel & Grau/Doubleday, 2008)

INTRO
LOUIS E.V. NEVAER

ILLUSTRATIONS FROM THE INSIDE:
THE BEAT WITHIN

I

The United States incarcerates more of its youth than any other nation in the Western world. Of the youngsters who run afoul of the law, many become repeat offenders simply because our criminal justice system is more successful at punishing than rehabilitating.

There are many reasons for the high rates of recidivism, but they revolve around the reality that juvenile offenders bring with them the emotional baggage of broken homes, poverty, social alienation and fears that characterize their lives as they meander through the criminal justice system.

Without a doubt, there are countless professionals who dedicate their careers to helping youthful offenders, teaching and counseling them so that they can be productive, law-abiding members of society once they pay their debt to society. It is a noble goal, but one that is, tragically, seldom achieved. Many professionals become disappointed and discouraged, frustrated and indifferent.

There are enormous obstacles that America's incarcerated youth confront. For too many of them, the circumstances in their lives— material deprivation, crime, alcohol, violence, substance abuse— await them when they leave detention. Every day, young people are released back into the community, without the necessary skills to overcome challenges, only to return to the homes, neighborhoods and lifestyles that led to their running afoul of the law.

Many youthful offenders become more skilled in crime, cynical about life, hardened and cold, a cycle that leads them down the path to a life of alienation and crime. "Most of the fights were bare-fisted," Dwight Abbott writes in his memoir, *I Cried, But You Didn't Listen.* "They usually happened on the spur of the moment. Most kids preferred bare-fisted fighting. It made for a shorter fight. I lost count of how many fights I saw the first week. There were dozens. Proving yourself is a way of life in juvenile institutions. Though against the rule, it is condoned by the majority of counselors as an acceptable manner in which kids can settle their differences. It's how boys prove they're men." The result of this brutalization makes for dehumanization. This is how Dwight Abbott describes the cumulative impact of this violence on his life: "I became less talkative, more difficult to draw into conversation. I had accomplished what all kids set out to do from the moment they are locked away—to place our peers and even members of our own cliques in total fear and awe."

Dwight was a member of white racist gang, The Aryan Brotherhood, one of the more feared prison gangs in California. In his experience, the "system," as criminal justice for youthful offenders is called, failed him. "As I struggle to come to terms with my future—or should I write the lack of a future now that I have been sentenced to four consecutive life terms—there are moments when something as simple as a sound will remind me of the deep well of sadness and isolation where I spent most of my childhood; of a time when I had to grow up fast for the sake of my own emotional survival," he wrote in 1991 at the age of 34. "Even as a pre-teen, I was aware of the cold indifference of the world, and I understood that strong self-reliance was imperative if I was to cope with the cruelties life would often inflict."

II

Race is the unanswerable American riddle, from which all social issues flow. "The disproportionate representation of racial or ethnic minorities [in the nation's prisons,] is also found in all stages of the juvenile justice system," states the report, "And Justice for Some," published by the National Council on Crime and Delinquency reported in January 2007. "Some have argued that this overrepresentation of youth of color in the justice system is simply a result of those youths committing more crimes than White youth. However, a true analysis is much more complicated. It is not clear whether this overrepresentation is the result of differential police policies and practices (targeting patrols in certain low-income neighborhoods, policies requiring immediate release to biological parents, group arrest procedures); location of offenses (African American youth using or selling drugs on street corners, White youth using or selling drugs in homes); different behavior by youth of color (whether they commit more crimes than White youth); different reactions of victims to offenses committed by White and youth of color (whether White victims of crimes disproportionately perceive the offenders to be youth of color); or racial bias within the justice system."

What emerges, then, is a system in which by virtue of being disproportionately from single-parent households, living in underprivileged neighborhoods, having fewer adult male role models or mentors stacks the deck against America's at-risk youth. Whether one looks at inner

cities or rural communities, where there are few civic resources to help troubled youngsters, where there are overworked police departments and where communities have burdened court systems, one sees high rates of recidivism among youthful offenders. For youth of color, the cumulative impact is astounding.

Consider that while African Americans constitute 16% of the nation's youth, they represent:

- 28% of juvenile arrests.
- 30% of referrals to juvenile court.
- 37% of the detained population.
- 34% of youth formally processed by the juvenile court.
- 30% of adjudicated youth.
- 35% of youth judicially waived to criminal court.
- 38% of youth in residential placement.
- 58% of youth admitted to state adult prison.

There it is, in numbers: What happens to youth of color in their first interactions with the legal system informs where they will end up as adults.

III

Into this bleak landscape, enters hope.

In 1996, a social counselor at the San Francisco's Youth Guidance Center wanted to provide a forum for the anguished voices of California's incarcerated youth. There was no mechanism for these troubled youth, many of whom were high school dropouts, to express themselves through words and images.

The Beat Within, a program that creates a dialogue among incarcerated youth through words and images, evolved from a series of workshops that took place that year. One reason youths end up in trouble with the law is that they are frustrated at school, often faring poorly. For many incarcerated youth, the power that comes from writing and drawing is not known.

When I returned to San Francisco in the summer of 1995, I was staying at the Park Lane Apartments, when I found myself attending the Monday morning editorial meetings at Pacific News Service. Through Sandy Close's generosity, I became familiar with the outreach programs for incarcerated youth, youngsters involved in gang violence and efforts to help misguided young adults make more life-affirming choices for themselves. In one corner of the office one found a peculiar mix, gang-related artwork on the walls, phones ringing off the hooks with probation officers wanting to know the whereabouts of so-and-so, stacks of notebooks that resembled lesson plans and a frazzled staff of two or three adults who were always running off to juvenile detention centers, prisons or the courthouse.

In the midst of all this, the power of words and images figured prominently. In a world where guns, violence and drugs destroyed life, there was the undaunted belief that words and images on paper would give young offenders a new vocabulary for expressing themselves, communicating with others and attaining the self-confidence that comes from being articulate in spoken and written words, and through the power of visual images.

Now a weekly magazine that provides a continuous dialogue, *The Beat Within* is a decade old. "*The Beat* provides something that few of these youngsters have ever known: a view of themselves as having self-worth, and having something worthwhile to say, a sense of belonging to a community of writers, and an interactive and positive relationship with the adults who facilitate *Beat* workshops in their units," David Inocencio, *The Beat's* Director at Pacific News Service, which operates the program, explains. "Every single published piece in *The Beat* gets a written response, allowing for an ongoing dialogue."

This program is a lifeline for many incarcerated youth, a realization that affirms the validity of their experiences, and the catharsis that comes from realizing that one is not alone.

IV

Historically, visual art has offered a refuge to those who have believed themselves to be on the margin of society. Outsider images, illustrations and design inform the periphery of our social landscape. The disobedient, defiant and excluded have found bold affirmation identity through — literally — writing on the wall. Whether it is the social mosaic of protest that constituted the graffiti of the Berlin Wall, or the tags and stickers on the walls of New York's legendary music club CBGB, or the expressions of hope for those "missing" in the wake of the terrorist attack on New York on the morning of September 11, 2001, it is a democratic expression, the *vox populi* of spontaneous graphic imagery that conveys messages by and for the community.

Humans deal with trauma differently. A community may protest a wall that divides their city, their country, their soul by defacing it. Alienated youth might scrawl their messages on the walls of a club throughout the decades creating a record of music as a form of social protest, spiritual identification and cathartic release. Desperate residents of a wounded city deface public places by posting images of and messages for those lost to terrorism, as much an expression of hope as a declaration of love for someone vanished. Visual images constituted a collective historical document, one whose poignancy reflected the circumstances that guided its evolution into our social consciousness.

That a disproportionate number of America's incarcerated youth are black and Hispanic (including Latino), offers its own irony: the nation's two largest minorities are linked by a shared history. In the first half of the 20th century, Social Realism in the United States reflected a strong Mexican influence. The politically socialist art of Mexican muralists such as Diego Rivera and José Clemente Orozco spilled across the border and captivated the American imagination. The sweeping panoramic social vision of the murals these Mexicans painted in New York, San Francisco and Detroit captivated the African American mentality.

It is a common history of mutual respect and journey of empowerment that has been forgotten. At a time when Black and Latino gangs prey on each other, often "tagging" territories in urban cities with "branded" graffiti, African American and Hispanic youth do not realize that theirs is a common visual history, one that emerged from the Social Realism born from the suffering inflicted on both sides of the border by the Great Depression.

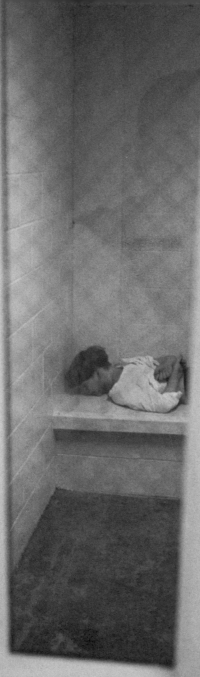

A 12-year-old waits in a holding cell in isolation. He was placed here for kicking a counselor. He had refused to go to juvenile hall but his mother insisted saying he was "too unruly." San Jose Juvenile Hall. San Jose, California, 1999.

Forgotten on the streets, it is being rediscovered behind bars, as incarcerated youths, of every hue of brown on earth, sit side-by-side, as they create art, as much for themselves as for others. This is the power of *The Beat*, and the visual art it inspires and nurtures.

V

The images created by America's incarcerated youth of color have this shared, proud history. Naysayer critics denounce this program, of course, arguing that these young offenders, especially those imprisoned as punishment for vandalism—defacing private and public property with their graffiti—should not be allowed to improve their skills. Once they are released, these critics argue, their time behind bars will have served only to increase their skills as vandals.

These critics miss the point. They fail to see the hope that grows when youths see their skills improve, when they are encouraged, when they receive praise from their peers. The images in this book are representative of America's incarcerated youth, from the pre-teens in juvenile detention facilities, to convicted gang members entering their early 20s. They represent the images that captivate them, reflect the ideals to which they strive, the visuals that have informed their lives: iconic images that deface warehouses, graffiti that defaces buses and trains, visuals of vandalized public spaces.

I became aware of the yearnings among incarcerated youth to express themselves when I had the unexpected opportunity to spend time with them, first at Riker's Island in New York, and then in San Francisco County Jail. At Riker's Island most of the offenders spent their days drawing doodles, or trying to write lyrics for rap songs. Most were high school dropouts, and some wanted to improve their reading and writing skills in order to get a G.E.D. credential.

Tyrone was an African American, aged 17, who was at Riker's Island, for the sixth time, arrested this time for selling drugs. He had two children, by two different girlfriends, neither of which he supported. His grandmother helped with the older child, a toddler. He would sit in a corner, making elaborate drawings, similar to the psychedelic images popularized during the 1960s. He confessed that he failed his G.E.D. exams simply because he could not understand fractions. "Maybe I'm just too dumb," he said. Or maybe, with overcrowded schools and an unstable home life, no one had taken the time to sit down with him and patiently spend an afternoon going over and over and over the material, explaining it different ways, until he understood. Where once he had fallen through the cracks of the public schools, in a single afternoon, he grasped the fundamentals of decimals, fractions and percentages, which would lead to ratios and proportions, which would lead to algebraic reasoning, which would lead ultimately to a G.E.D. credential.

His images began to include numbers, fanciful fractions emerged from the imaginary murals he would one day paint on the side of a building, he said, so his community would "come into unity = community."

There were different concerns among the youthful offenders at San Francisco County Jail that I met at the end of 2004. Where Tyrone

only had a Number 2 pencil for his drawings, Joey had a set of colored pencils, and an entire notebook he filled with fanciful images. An overweight young man, Joey had been arrested after he robbed the Bank of America branch on the corner of Market and Van Ness Streets in downtown San Francisco. For him, the third time being a bank robber wasn't the charm; he was now winding his way through the criminal justice system. "I draw what I love: money," he said, doodling dollar signs and hundred-dollar bills, with his self-portrait replacing Benjamin Franklin's image. Although he had graduated high school, he had never gone on to college, and his cultural literacy was incomplete. "Andy Warhol did a series of paintings that focused on money," I mentioned to him one afternoon, after he had tired of Scrabble and had taken out his notebook. "Who's that?" he wanted to know. In a different time, under different circumstances, his clever illustrations of money would have found admirers, perhaps even gained currency among collectors.

"We are so perverted by an education which from infancy seeks to kill the spirit of revolt, and to develop that of submission to authority; we are so perverted by this existence under the ferrule of a law, which regulates every event in life—our birth, our education, our development, our love, our friendship—that, if this state of things continues, we shall lose all initiative, all habit of thinking for ourselves," Peter Kropotkin wrote in *Law and Authority*.

The year was 1886.

Tyrone and Joey sit in cells on the opposite coasts of the nation, but they are linked by a visual language of imagery. It is true that certain of these young offenders become more apt in the skill set that landed them in trouble. It is also true that they can exercise free will. "I'm about rescuing lost and violent persons from themselves, prison and from society and cleansing them and sending them out to live normal, healthy, productive, happy lives with love and hope in their hearts instead of anger and violence," Del Hendrixson, founder of Bajito Onda, says. "The reason I know? I used to be one of them." "Bajito Onda," Spanish slang for "underground scene," is a nonprofit organization that makes commercial use of the artistic skills of incarcerated youth, once they have been released. A safe space for former gang members, one of the few criteria for employment, apart from a willingness to work, is that everyone complies with the conditions of their probation.

"We all have a future no matter where we have been," is the motto of this graphic design and print shop, a successful commercial enterprise, which provides careers to former "vandals."

VI

In each issue of *The Beat*, verbal and visual portraits of juveniles' lives emerge, bold affirmations of their life experiences, startling realizations that they are not alone in what they feel, what they think. There is rage, and there is despair. There is also hope, exuberance, life restrained seeking to be unbound, set free, but realizing there are obstacles.

For those of us on the outside, by becoming an audience to the images of America's incarcerated youth, we have the ability to become more than spectators, but serve as mentors, understanding and sympathetic. It is a testament to the dedication of David Inocencio and Michael Kroll at Pacific News Service that they spend long days editing

and assembling the contributions of thousands of youthful offenders into a weekly magazine for and by kids on the inside. These images, assembled and published here for the first time in a book format, will reach an audience, from the family members these youngsters feel alienated from, to the police officers who make arrests, to judges who impose sentences, to probation officers who are the institutional link between the criminal justice system and the community at large.

We have a role to play, as members of society. We have the ability to recognize the undeniable humanity of those who have committed a crime against society by violating our laws. We have a role to play, to encourage them, whether it is showing one young man at Riker's Island the logic of fractions, or sharing with another one in San Francisco County Jail the legacy of Pop art in using the symbolism associated with money as a valid subject for serious art.

We do this, nay, you do this, because it is your communal responsibility to help society's young people, particularly the most vulnerable, the ones who have gone astray, the ones that need a little bit more help than others.

You want them to feel empowered by their creativity, their ability to express themselves in written words and graphic images. You want them to feel validated, to realize that they have earned your respect. You do that because helping the young is our moral duty.

See that? See that? Do you see that? That is the image that tells your story, the image that will change your life. You want them to believe you when you tell them that, so that they can believe in themselves.

New York, New York, 2007
To support The Beat Within, go to TheBeatWithin.org

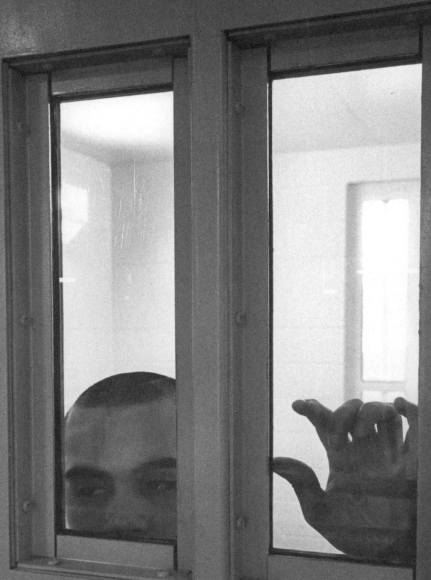

Edward is 17-years-old and has been in the system since he was 12. He was caught for many illegal activities from being in possession of beer at school to auto theft. During his trial, lawyers noted that his criminal sophistication was beyond his years. This time he is being jailed for raping his half-sister, a minor, after she'd had mouth surgery and stayed home to recuperate; she'd already been a victim of his father's sexual abuse. Edward has been sentenced to 12 years at San Quentin. Now he is locked-up in the B-8 unit, a special maximum-security unit for severe cases of high-risk youth. San Jose Juvenile Hall. San Jose, California, 1999.

A twelve-year-old boy is being photographed at the receiving department of Santa Clara Juvenile Hall in San Jose, California, 1999.

Privacy laws throughout the nation

are designed to protect offenders under the age of 21. In many cases, youthful offenders can have their records sealed upon reaching adulthood, giving them an unblemished fresh start, which is often instrumental in leading lives as successful and responsible members of society. For this reason, it is not possible to identify contributors who are younger than 21 years of age by name. We have, however, provided a general description of the artists whose works are included in this book, allowing readers to understand the individuals behind the art. Some of the contributors who are today over the age of 21 are identified by name. Ten have made video diaries which are available at TheBeatWithin.org.

"Adult" is anyone over 18 in some places, or over 21 in others. An offender has to be a juvenile when arrested, charged, prosecuted and convicted (or enter a plea) to qualify for *The Beat Within*. If you are 17 and get a five year sentence, you'll be 22 when you are released on probation; you are therefore "grandfathered" into the program, but anyone over 25 goes to the Adult Prisoner Writing programs—PEN operates some of those. No one in the program is older than 25; there are a few prisoners who were sentenced to life for murder, but after they turn 25, again, they "graduate" to a different writing program—for adults.

The themes that emerge throughout the nation's juvenile detention centers among young offenders reflect a longing for identity, a reason to be proud of who they are and what they contribute to the world. Cultural anthropologists remind us that those whom see themselves as oppressed search for validation. The story of our nation is the struggle for inclusion: African Americans to be accepted as equals, women who struggled to be enfranchised, gays and lesbians to overcome social bigotry. In many of the images here one sees how Hispanics and Asians romanticize their cultural heritage, whether it is an Aztec pyramid or Eastern martial arts, to validate their existence. "We are not a minority," is the declaration, and without a doubt, minorities will become the nation's plurality by mid-century.

Clowns are icons identified with Latino gang culture in the United States, from California to Texas, as a metaphor for hiding one's feelings in Latin American culture, where stoicism is identified with manhood.

Male juvenile Latino gang member; Alameda County Juvenile Hall, California.

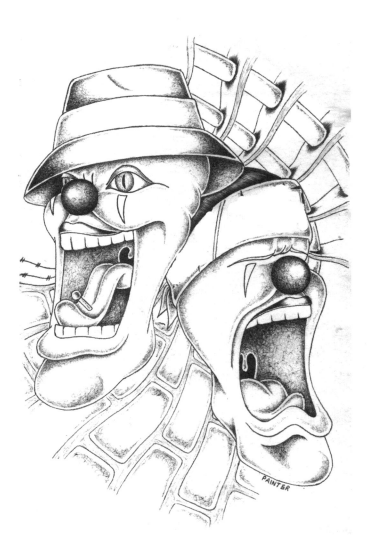

Alex Shelton; Caucasian gang member; Los Angeles, California.

Alex was 15-years-old when first arrested.

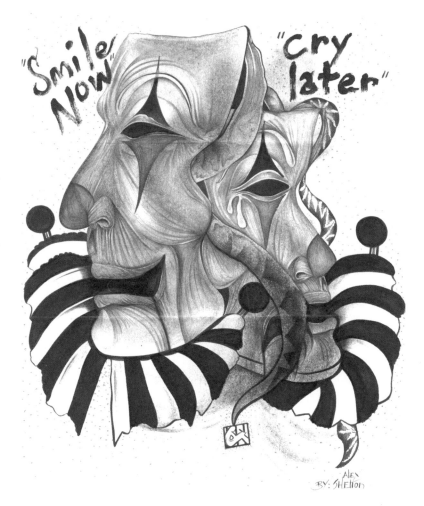

Alex Shelton; Caucasian gang member; Los Angeles, California.

Alex was 15-years-old when first arrested.

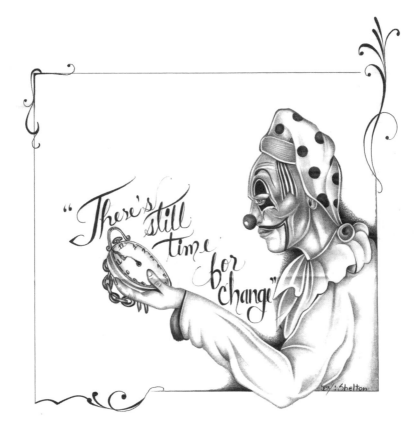

"There's still time for change"

By: Shelton

Juvenile Latino gang member; aggravated assault and fraud; East Los Angeles, California.

Arrested as a teenager, he will not be released until he is an adult.

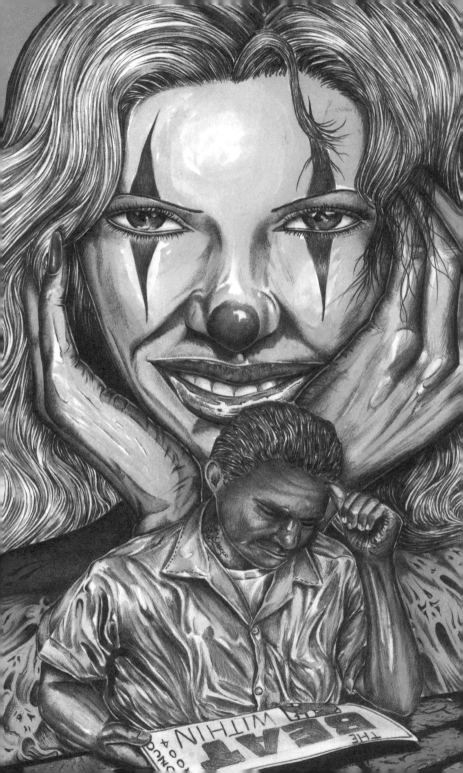

Michael Orozco; Pelican Bay State Prison, California.

Michael began to contribute to *The Beat Within* when he was first arrested as a teenager.

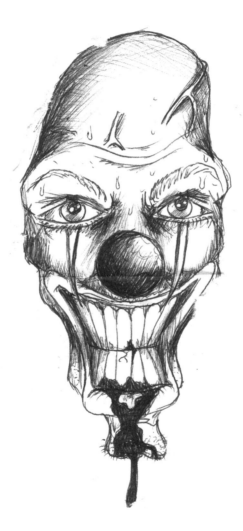

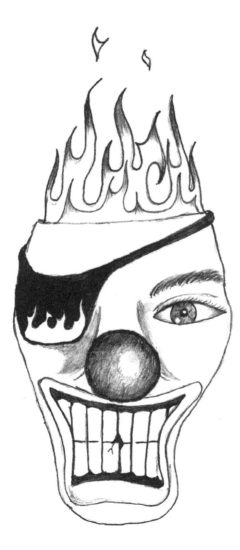

Latino male juvenile, age 15.

This illustration combines elements of Hispanic and Anglo-American popular culture.

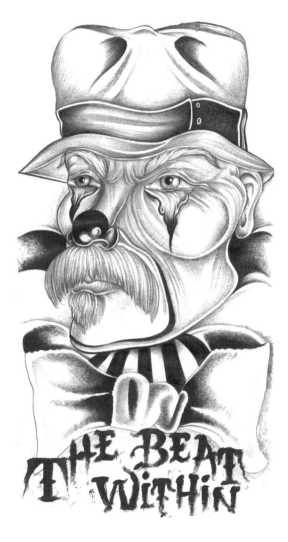

Jason Treas; Folsom State Prison, California and Pelican Bay State Prison, California.

Jason is now an adult, living and raising his family in the San Francisco Bay Area.

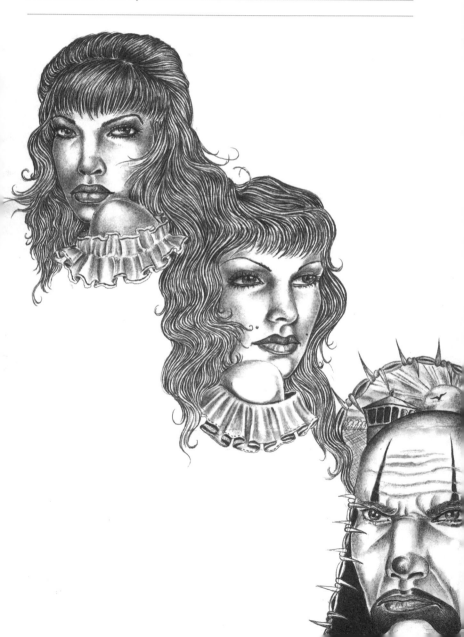

Alex Shelton; Caucasian gang member; Los Angeles, California.

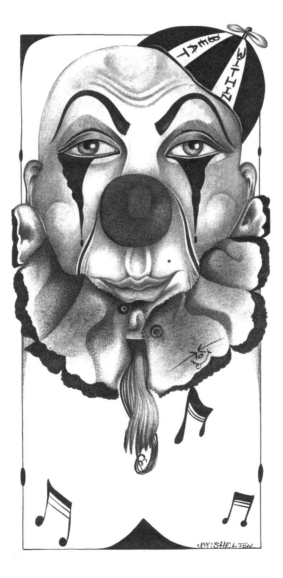

15 year old Hispanic juvenile; gang-related violence; Arizona.

The imagery invokes the Sacred Heart of Christ, a familiar image throughout the American Southwest and Mexico.

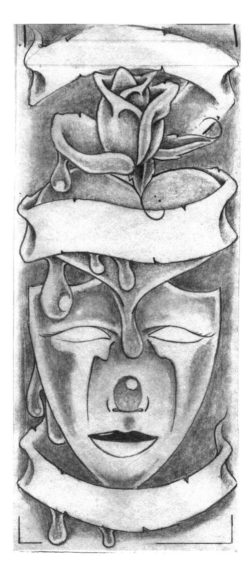

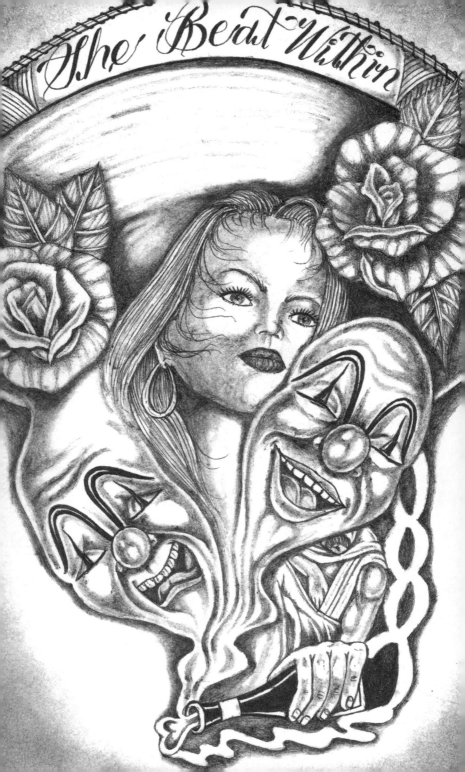

Omar Turcios; 21-years-old; gang-related violence; San Francisco, California.

Today Omar is still very affiliated with *The Beat Within* as a typist, helping to put out the weekly magazine. Omar lives in the San Francisco Bay Area where he is raising his family.

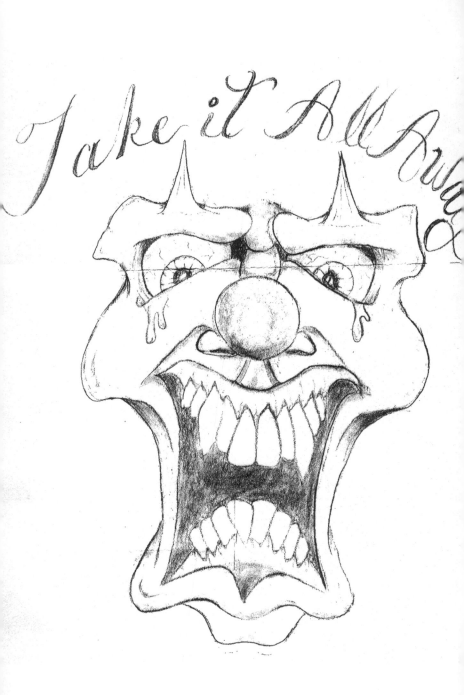

Time To Change by "Toni"

It's a struggle to keep up with the game
Ya gotta work hard to keep gettin' your fame
To survive you gotta travel through the wrong lane
But there's an easier way, but you gotta use your brain

You gotta stop being wild and start acting tame
Start going to school even if people say you're lame
Treat people polite so they won't think you're insane
If you follow that advice there'll be so much you can gain
Don't end up like some of us facing time in the "Y"
Waiting 'til the last minute to pray to the Lord in the sky
Quit spending all your time trying to look fly

Half the stories y'all say are a lie
Every time you get in trouble you make an alibi
But the life you choosing is like choosing to die
I went to court yesterday, they said I was crossing the line
I got lucky I didn't go to the "Y" but I'm running out of time
When they said that, it brought me to life, it was like a sign
It was because of all those group homes I chose to decline

It was my fault; I chose to commit the crime
I always stayed out there trying to sell that last nickel and dime
Reality hit me; I gotta get my shhh straight
I can't let a lifetime in jail be my fate
It's time to change!

In contrast to Latinos, Native American and African American offenders are more emboldened in their portraiture. Native Americans tend to strive for an idealist representation of their indigenous culture before the arrival of Europeans (free, exiled or indentured) and Africans (some free, most enslaved). In contrast, African Americans embrace contemporary culture, particularly rap music and its icons, in a bold affirmation of identity.

FACES

Native American male juvenile arrested at age 15; Northern California.

He is not expected to be eligible for parole until he is 22.

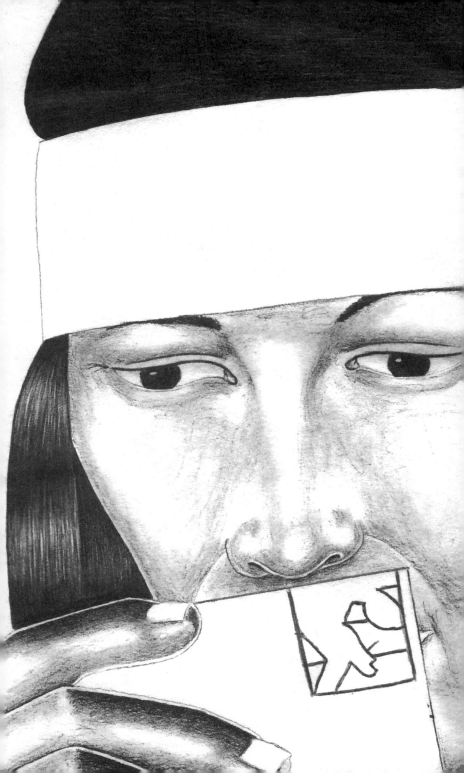

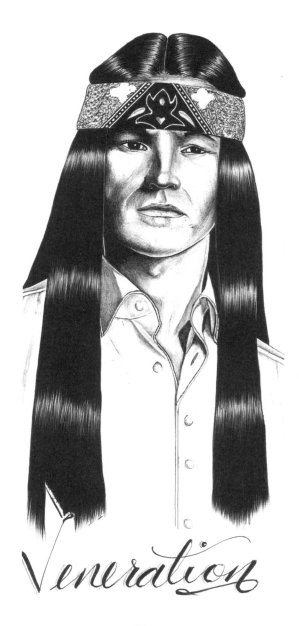

Veneration

African American male juvenile; 14-years-old.

Inspired by a class while in juvenile detention, this teenager had only learned about Booker T. Washington and Frederick Douglas after being imprisoned.

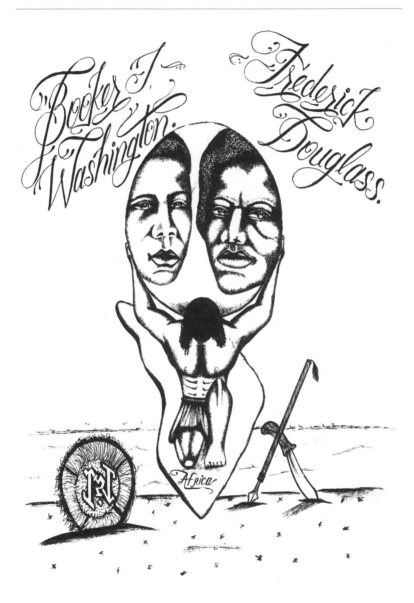

REV. RUN. OF. RUN. D.M.C.

African American male in his early 20s; Pelican Bay State Prison, California.

BLACK N MILD. 2009.

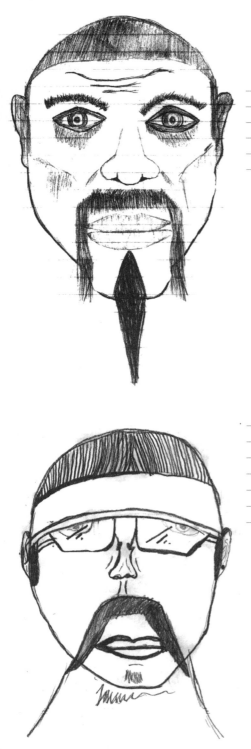

Asian male juvenile in mid-teens; Los Angeles Juvenile Detention Center, California.

Native American male juvenile, age 12; Los Angeles Detention Center, California.

A self-portrait.

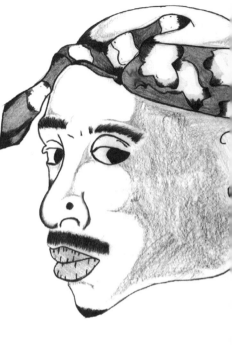

Janea Asis.

Incarcerated at the age of 17, she subsequently worked for *The Beat Within* for two years after her release. Her whereabouts at present are unknown.

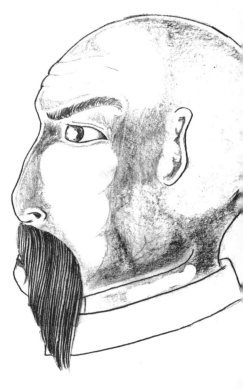

Asian male, age 14; San Francisco Juvenile Hall, California.

African American male juvenile, age 16; Alameda County Juvenile Hall, California.

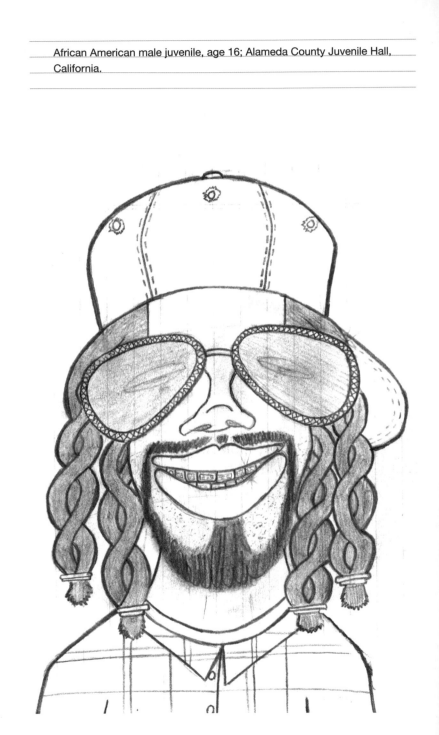

African American male juvenile, age 16; Alameda County Juvenile Hall, California.

African American male juvenile, age 14; San Francisco Juvenile Hall, California.

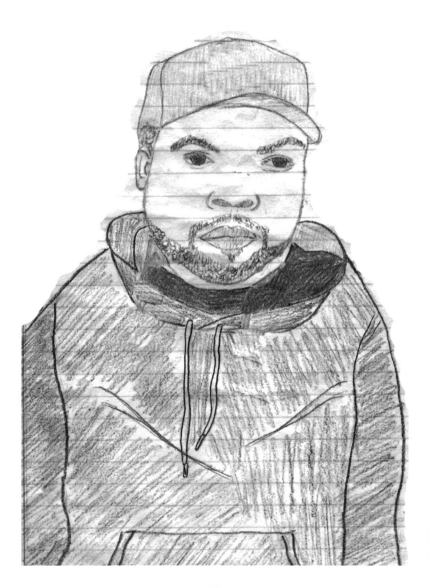

African American male juvenile, age 12; Alameda County Juvenile Hall, California.

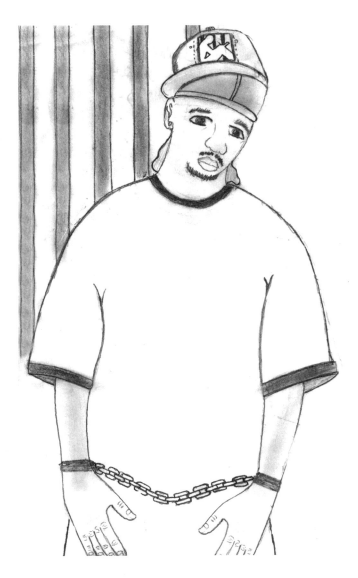

African American male juvenile, age 15; drug-related charges;
New York State Prison System, New York.

Allan Martinez; gang affiliation and drug dealing.

Now in his mid-twenties, Allan is currently an editor at *The Beat Within*, and also responsible for translating text into Spanish.

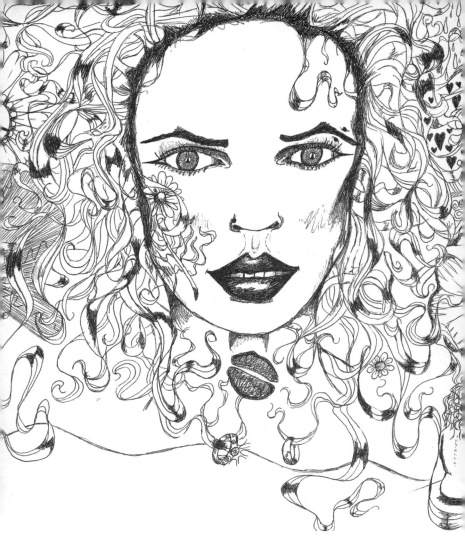

Marin County Juvenile Hall, California.

A teenage offender who served time for more than a year as prosecutors sought to have him tried as an adult. Today, he is free and living with his family in New Mexico.

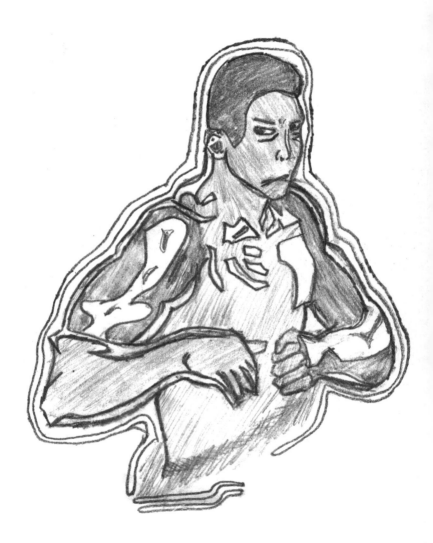

Who Failed, What Failed? by "Brendan"

Society never failed.
They say it was all me.
After all, isn't that the reason the court calls me guilty?

It was not my family.
They're trying to do what is best.
That's why they turned me in, placed me under arrest.
And it was not the cops that bruised my wrists.
It was the cuffs clamped too tight, even though I did not
resist.

And the shirt that was ripped as they threw me around
didn't matter at all, because I was screwin' around.
Was my family doing what was best when they smacked me
around because I fled school?

The teachers barely taught, and they never try to
understand. It's learning communication and support
that turns boys into men.

It's no one's fault but my own, and I do understand.
As long as society continues to lie, it is all my fault,
and I hold in the cry.

Skulls are a common motif used by Caucasian offenders, many of whom use "goth" imagery in their work. Although the public perception of Caucasian offenders is that they are followers of "Aryan" or "white supremacy" movements, the vast majority are not. Most youthful offenders follow "ska," a working-class, urban look and music style originating in England, which, along with metal, in this country is seen as a counterpart to rap music.

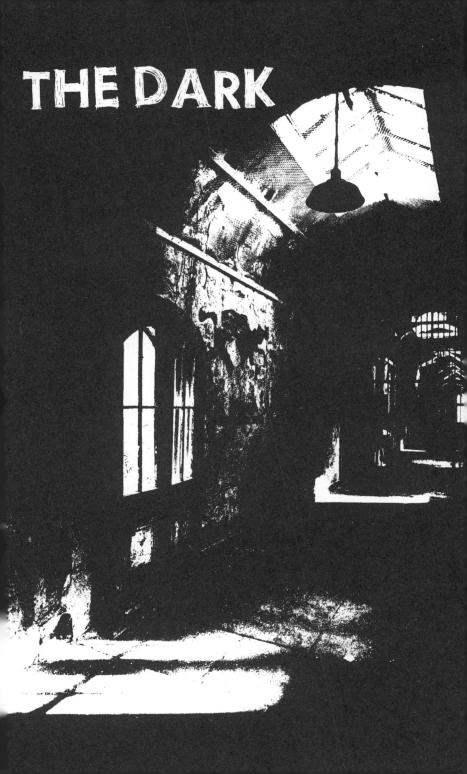

THE DARK

Ronnie Shelton.

"Puppet on a String," created by Ronnie Shelton, is a familiar theme throughout the California and Nevada juvenile detention systems. Currently serving time as an adult, Ronnie entered the prison system as a teenager and has been an avid contributor to *The Beat Within*, sharing life's lessons with younger prisoners.

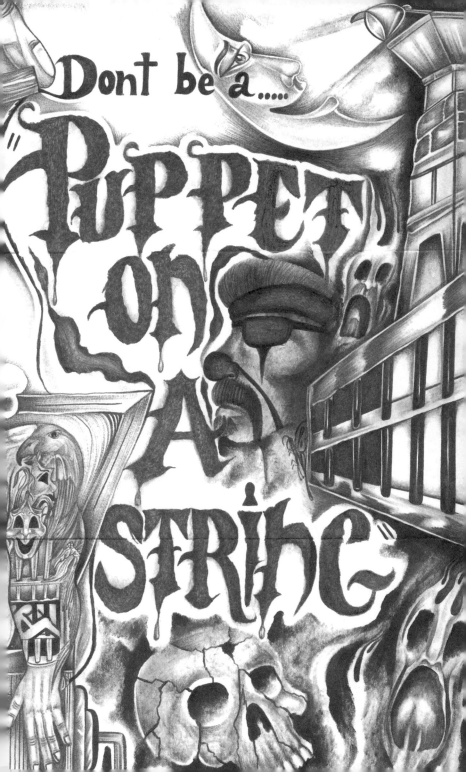

Caucasian male juvenile, age 13; drug possession.

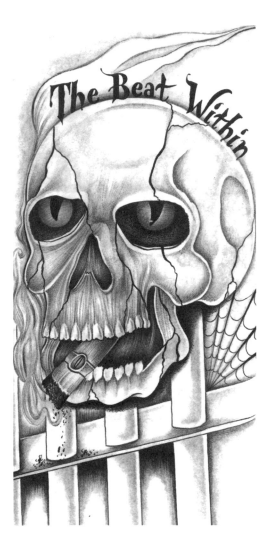

Caucasian male juvenile, age 16; Alameda County Juvenile Hall, California.

A "ska" image.

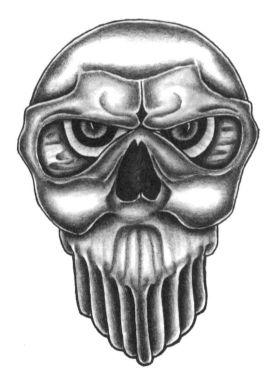

Male juvenile, age 12; New York State Juvenile Hall System,
New York.

African American male juvenile, age 14.

A self-portrait done while the juvenile awaited reassignment from
Nevada to the California prison system.

Caucasian female juvenile, age 16; drug possession and assault.

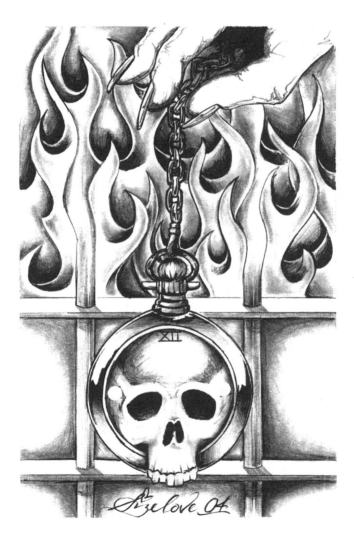

Male juvenile, age 11; San Francisco Juvenile Hall, California.

One of the youngest contributors to *The Beat Within*.

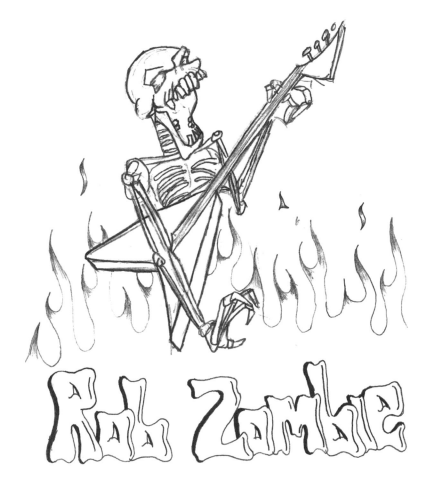

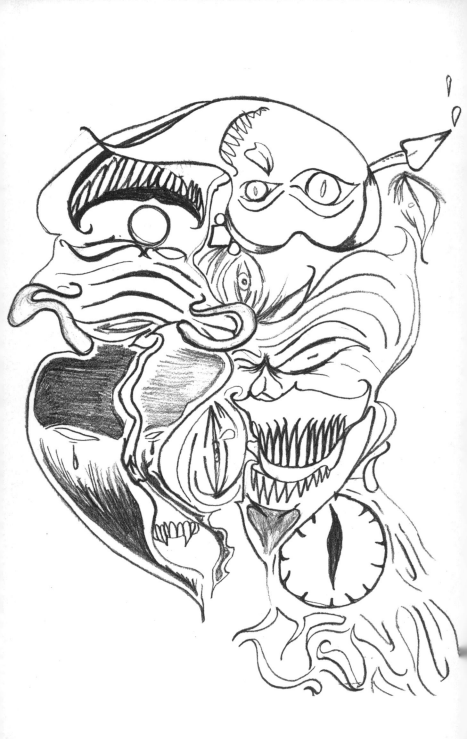

Will Roy.

Now 25, Will came into contact with The Beat as a 15-year-old fighting a robbery case. He is currently a facilitator for *The Beat Within*, as well as a public speaker. He is pursuing writing as a student at San Francisco State University.

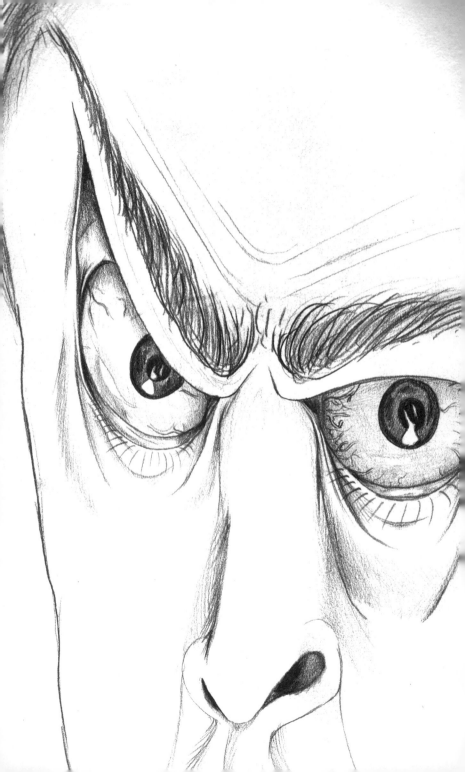

Caucasian male juvenile, age 16; Alameda County Juvenile Hall, California.

A "ska" image.

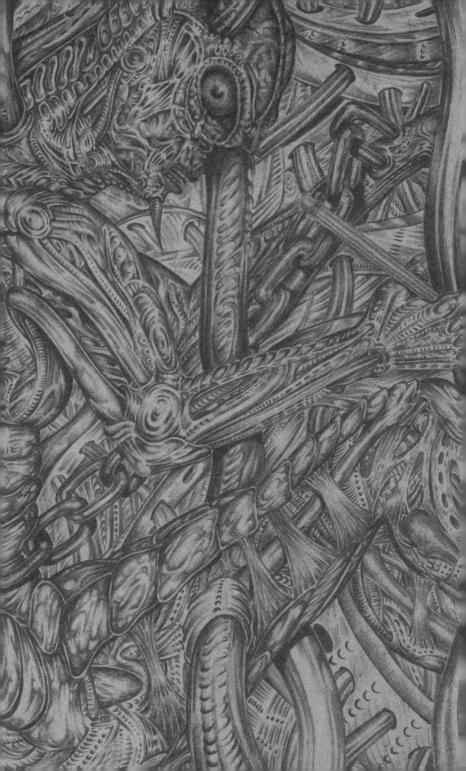

I Woke Up This Morning… by "Lil' José"

And I went to court.
I was hoping for a release
but that hope was to be deceased.
When I heard the judge say "six months in Camp
Sweeney,"
I really wasn't trippin'
But I was hoping for "released"
Now I gotta do my time,
It's all time to clear my mind,
To think of what to do,
Once I get free of time,
So when I woke up this morning
I asked myself,
How long will the judge mourn me
A "gangsta"?
A "thug"?
Will they some day show me love?
Or will the next step be the "Y"?
And then will I ask, "why?"
Or will I prevent it?
"Hell Yeah!"
But if I can't,
It's 'cause the "G" in me
Is doing its "G" thang
So when I woke up this morning
I seen my future flash before my eyes.

Cartoons are a universal form of expression, one that transcends cultures and allows younger juvenile offenders to express themselves. With a strong tradition of graphic story telling, youngsters of Asian ancestry identify with anime characters and their popularity.

CHILD'S
PLAY

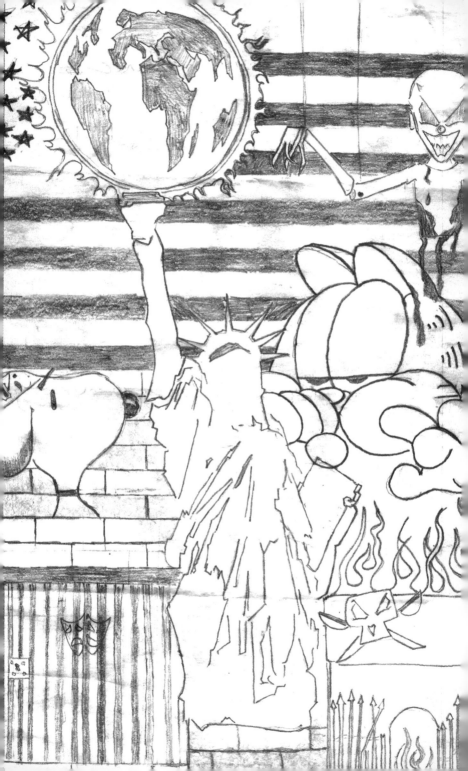

Asian male juvenile, age 13; gang-related violence; San Francisco
Juvenile Hall, California.

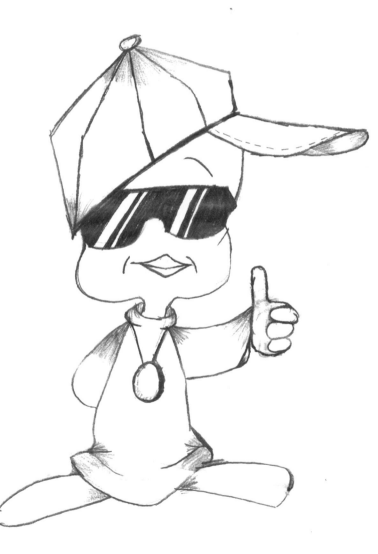

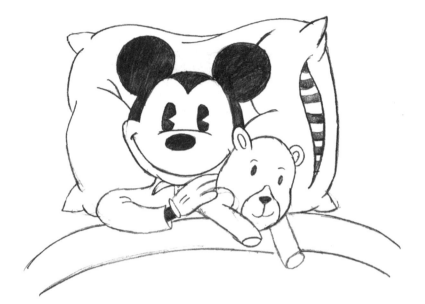

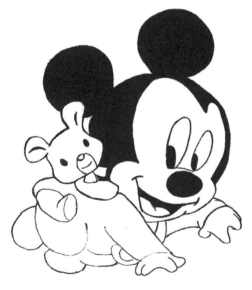

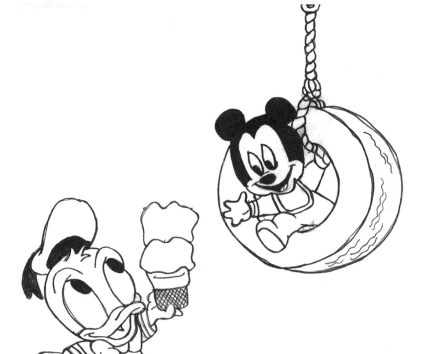

Asian female juveniles, ages 13 and 14; gang-related assault charges.

Asian male juvenile, age 14; Los Angeles, California.

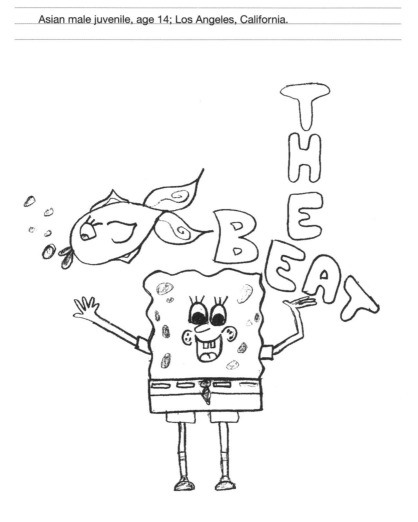

Caucasian male, age 12; San Francisco Juvenile Hall, California.

African American male juvenile, age 12.

Released on probation shortly after this drawing was made.

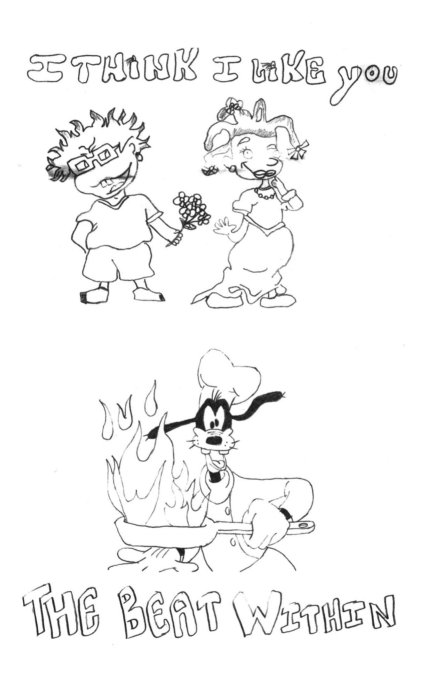

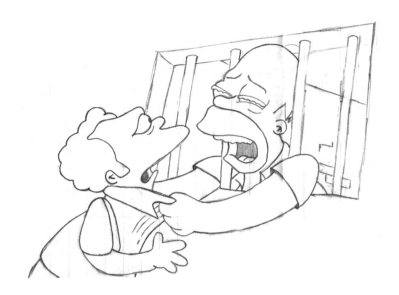

Caucasian male juvenile, age 17; Nevada.

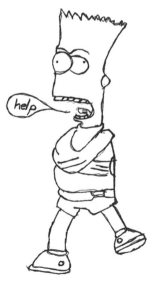

Latino male juvenile, age 13; Alameda County Juvenile Hall, California.

Asian male juvenile, age 14; San Francisco Juvenile Hall, California.

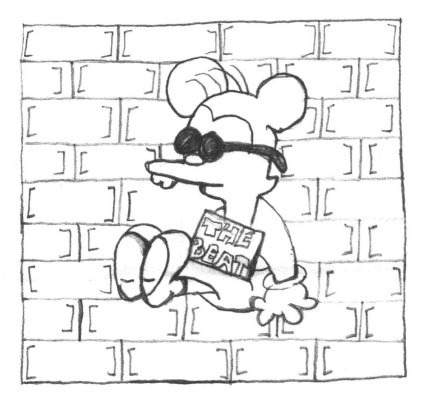

Latino male juvenile, age 13; San Francisco Juvenile Hall, California.

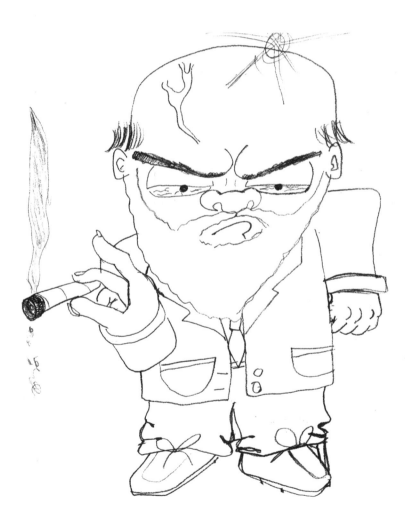

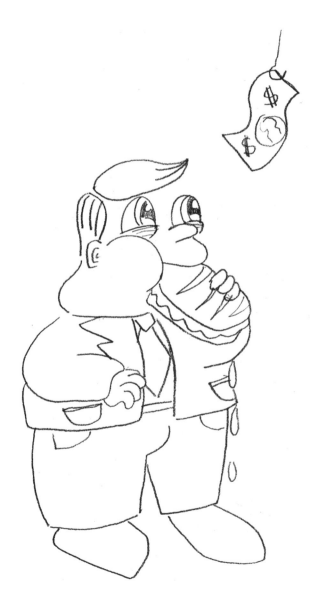

African American male juvenile, age 15; Alameda County Juvenile
Detention, California.

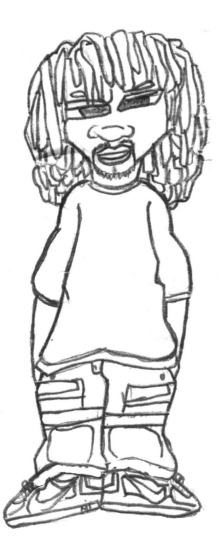

Gelle Tolbert.

Now 22-years-old, Gelle has been in and out of juvenile hall since she was 12. She, in fact, grew up with The Beat Within. She is currently free, a young mother raising her newborn child in the San Francisco Bay Area.

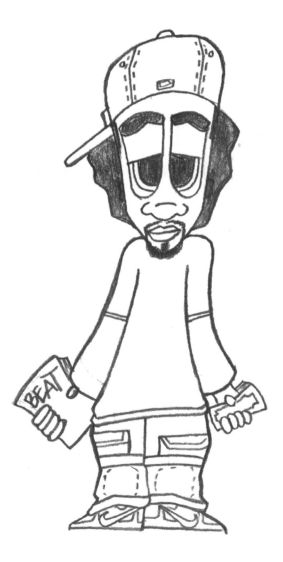

Asian male juvenile, age 14; gang-related charges.

Self-portrait of juvenile prisoner and his girlfriend.

African American male juvenile, age 16; Texas State Juvenile Hall, Texas.

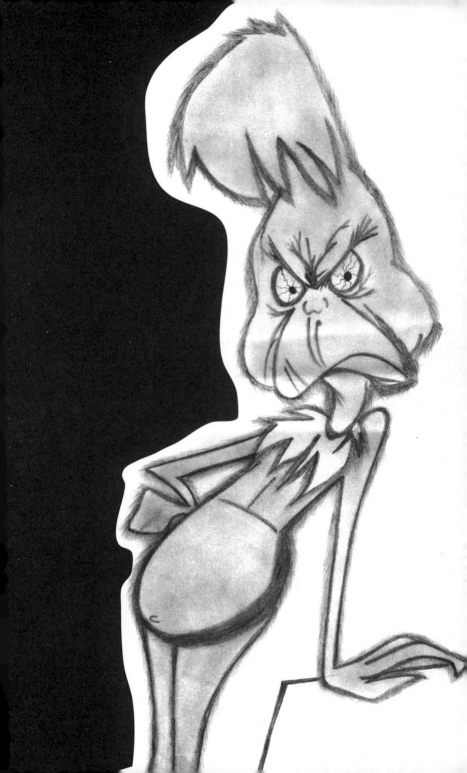

Ming Toy Lee.

Currently 28, she was first arrested at the age of 12, and came into contact with The Beat Within shortly after it was founded as a program for incarcerated youth. Upon her parole, she came to work at The Beat Within offices as a typist and peer mentor.

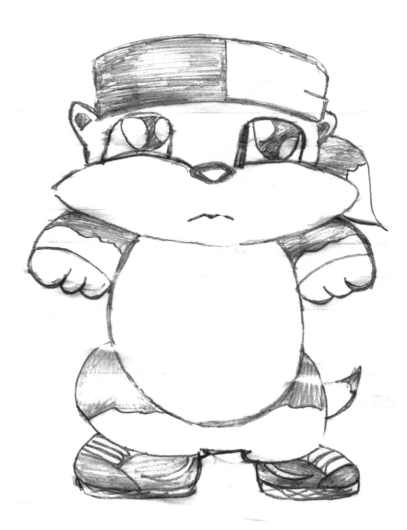

...ABOUT ALL THAT SWELLING?

?

HEY, IF IT AIN'T DEL, THE RED TERROR!

NOT MUCH, DUDE.

WHA'SAPP'NIN?

JUST GOT IN FROM GHANA WITH A FRIEND.

IZZ'AT RIGHT? AND WHO IS YOUR LOVELY FRIEND?

QUESTION 1: WHY, AFTER ALMOST A YEAR OF HOLLERIN' AT EACHOTHER IS LI'L RAE N'DELE H. MERDE...

HI YA' DOIN? I'M RUFUS.

HI RUFUS. I'M RAE.

GREAT! PERHAPS SOME TIME IN THE NEAR--

SORRY, BUBBA. BUT SHE'S ALREADY SPOKEN FOR. GOTTA RUN, DAWG.

...GIVIN' ME THE "PLEASED-TO-MEET-YA" DRAG?

BYE.

DEL...

...NOOO...

LIKE THEY SAY...

C'MON, MAN. YOU KNOW ME AND TA'KIA ARE TIGHT.

...IF AT FIRST YOU DON'T SUCCED, YOU CAN DUST IT OFF...

...AND TRY AGAIN.

SEE YOU AT THE **CLUB** TONIGHT, RUFUS!

2

QUESTION 2: IF SHE'S NOT *SHAGGIN'* WITH DEL...

...THEN HOW DID THOSE TWO HOOK UP?

FOR RAE TO ACT LIKE SHE DOESN'T KNOW ME, THOUGH... *SOME* THIN'S UP!

BUT MEANWHILE, OUT ON THE BAY... A MINUTE CONCERN FOR *RUFUS*, AS EVEN MORE QUESTIONS ARE ASKED ABOARD THE *GOTHMORDE* VESSAL "LIGHT FLIGHT..."

...THE SINGULAR THOUGHTS OF AN *INDIVIDUAL*.

THIS AIN'T COOL AT ALL!!

LECHT CITY'S OFFICIAL HEADS DEBATE THE ISSUES OF THEIR CITY'S FUTURE.

WHEN CITY + DISTRICT 'WIGS' GET UP TO *THIS* MUCH POSTURING...

©½ CYPHER '03

3

AND YOU EXPECT MY COUNCEL TO JUST ROLL OVER AND TAKE THAT KIND OF THANG DRY?!

...THAINGS CAN'T BE TOO GOOD!

WHAT MAKES YOU THINK THIS WON'T WORK?

BECAUSE WE CAN'T AFFORD IT!!

I'M NOT ALONE WHEN I SAY THIS WHOLE THING STINKS!

AND WHAT BECOMES OF OUR PRIVATE INTERESTS?

THIS JUST MAY CAUSE RIOTING!

LIKE A BUNCHA' KIDS FIGHTING OVER THE MOST POPULAR HOOCHIE IN SCHOOL.

BUT RIOTING IN WHOSE GODDAMN DISTRICT?!!?

BE SILENT!!

"...OR LAP BOY CREEDANCE WILL SMASH!" HA! HA!

ORIN CREEDANCE; CITY SQUAD GENERAL; AWARDED TOP KUDOS FOR LAST YEARS...

...CITY WIDE SWEEP OF DYSFUNCTIONALS. PROBABLY HIS REASON FOR BEING HERE NOW.

YURUGU, SECOND YOUNGEST OF HOUSE OBRYNTHE.

...YOU HAVE ALL BEEN SUMMON-ED HERE FOR THE APPRAISAL OF OUR NEW PROJECT.

PROPOSITION: METAFORM!

THIS PROJECT WILL RESTORE THE CITY TO ITS ONCE OPULENT POTENTIAL!

MAHRI ZINGHA, CHIEFTESS OF THE DJUHN PEOPLE.

A PROPER ALLY IF ONE SHOULD EVER HAVE NEED OF IT.

PROPOSITION: METAFORM WILL RID THE CITY OF LEONT OF ITS WASTED GRIDS.

THANK YOU, GENERAL.

LADIES, GENTLEMEN...

AND SHE'S CUTE!

THESE WILL BE BROUGHT BACK ONLINE AS THRIVING DOMAINS!

AND ALSO THE DEADLIEST OF THE CLAUS SIX DAUGHTERS.

...ELDERS...

African American male juvenile, age 16; Pelican Bay State Prison, California.

Asian male juvenile, age 17; Oregon State Juvenile Hall, Oregon.

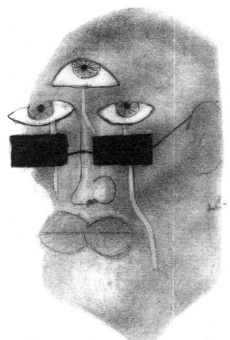

Tears down my soul

Outraged by "Lim"

I woke up this morning and felt outraged because
I'm still here. Every day feels longer and longer: the
same four walls, the same routine, the same food.
I'm getting sick of it.

I'm upset, because the system says you're innocent
until proven guilty, but I've been here for two and
a half months for something I didn't do,
but the law has other plans.

I'm just tired of being incarcerated
— it's taking away from my youth, but since I've been here I've
had a lot of time to think and look at my life and get my priorities
straight, but I'm making the best of it, and I know soon I can return.

We all search for identity by using the imagery and symbolism we know. In these illustrations, respective religious and cultural backgrounds are rendered with pride.

RELIGION
AND
CULTURE

Hanif Bey.

Now 32-years-old, Hanif was in his teens when he was first arrested. Hanif has one of the longest associations with The Beat Within, which he credits with changing his life. He is going to college, raising his family in San Francisco and continues to be an occasional speaker to troubled youth.

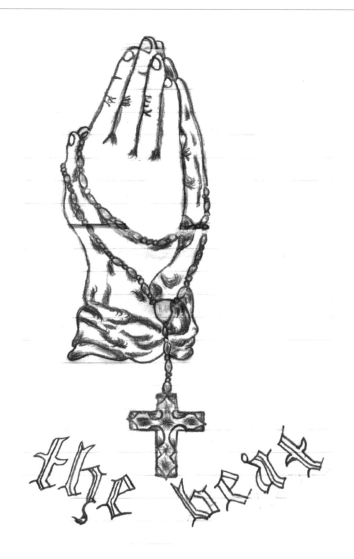

Latino male juvenile, age 16; San Francisco Bay Area.

Expected to serve time, depending on credit for good behavior, until he is 28-years-old.

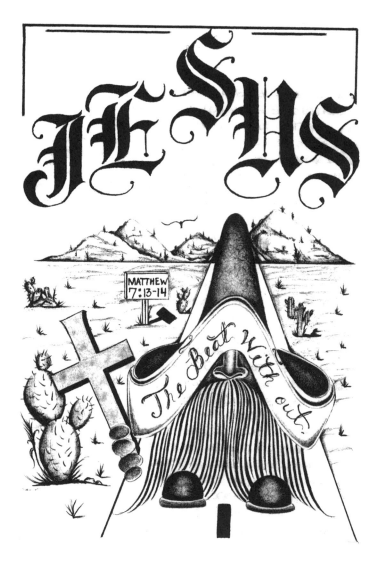

African American male, age 15; Los Angeles, California.

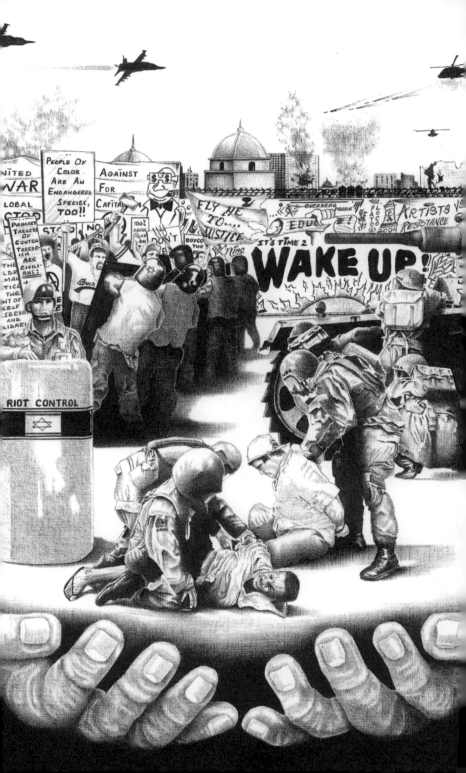

African American male juvenile, age 17; California.

Converted to Islam while in juvenile hall; he has been contributing to *The Beat Within* since his mid-teens, when he first entered the criminal justice system.

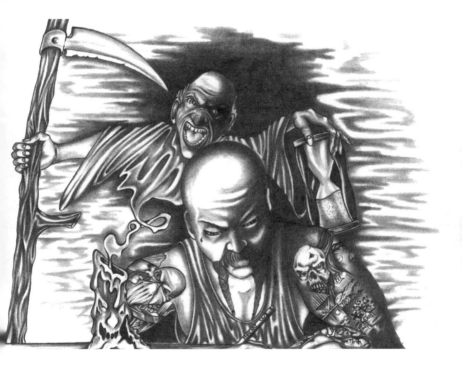

Asian male juvenile, age 15; gang-related violence; Alameda County Juvenile Hall, California.

Scheduled to be released when he turns 21-years-old.

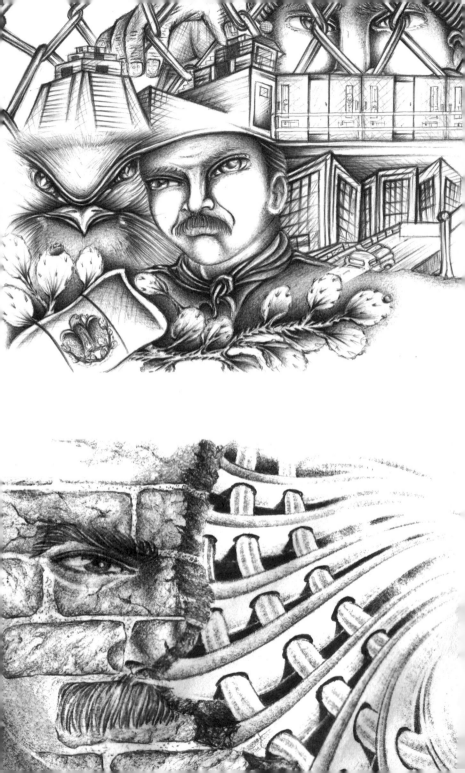

Marcello Baeua; gang-related violence.

Currently serving in an adult prison, Marcello has been contributing
to *The Beat Within* since his mid-teens.

Michael Orozco; Pelican Bay State Prison, California.

Now serving time as an adult, Michael began to contribute to *The Beat
Within* when he was first arrested as a teenager.

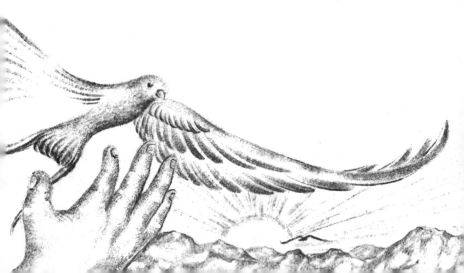

Michael Orozco; Pelican Bay State Prison, California.

Now serving time as an adult, Michael began to contribute to *The Beat Within* when he was first arrested as a teenager.

OPPOSITE PAGE:
Nguyen Dat.

Currently in the Corcoran State Prison in California, Nguyen first began contributing to *The Beat Within* as a juvenile offender.

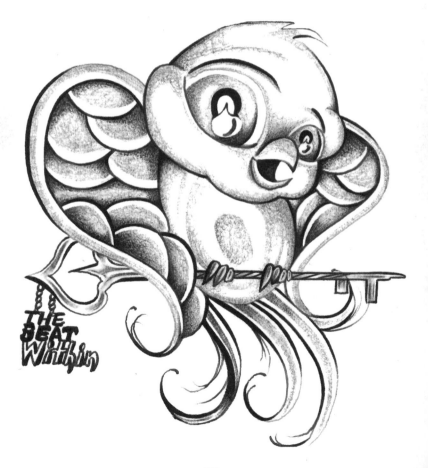

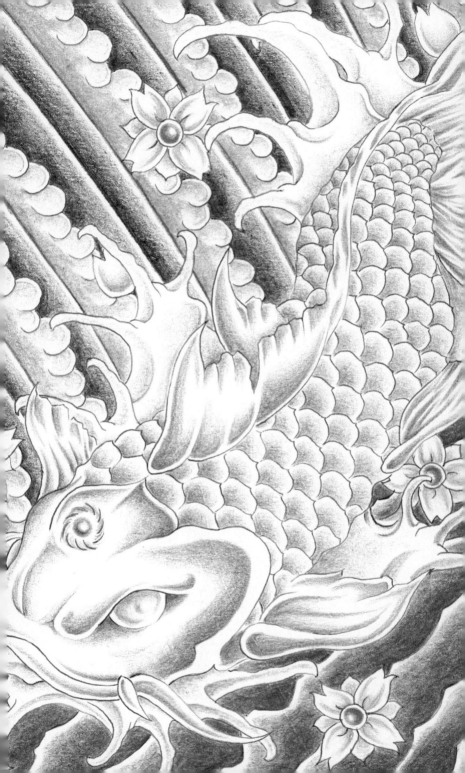

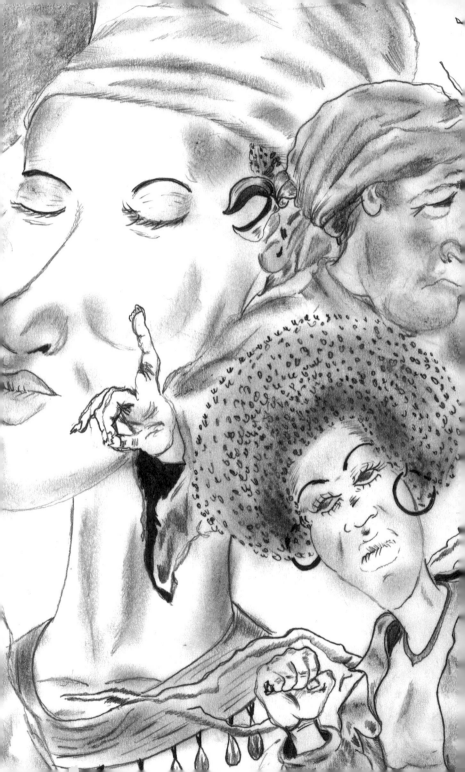

Nguyen Dat.

Currently in the Corcoran State Prison in California, Nguyen first began contributing to *The Beat Within* as a juvenile offender.

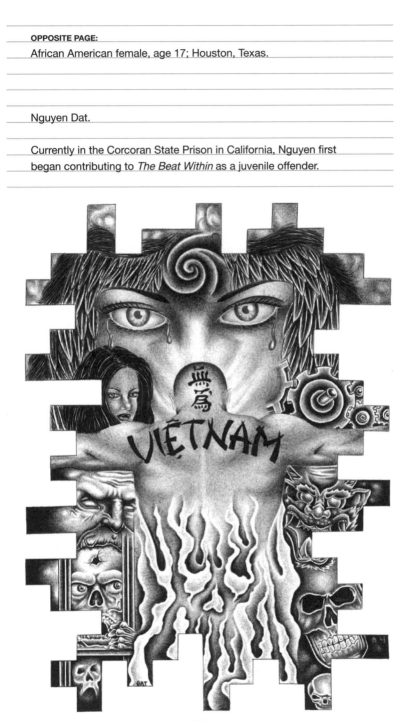

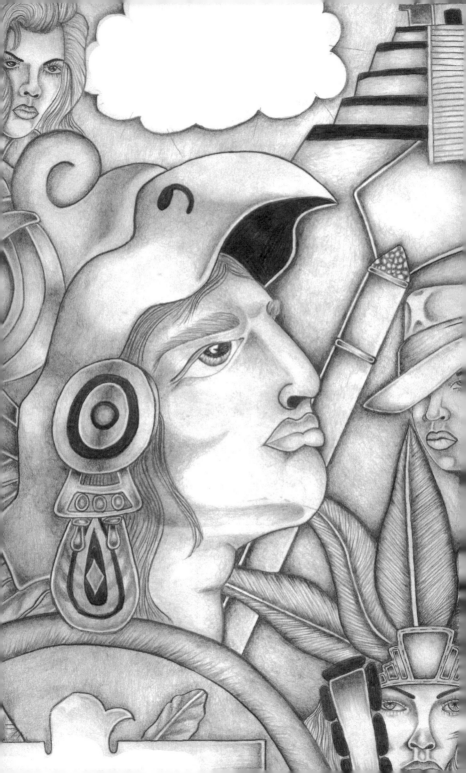

Latino male juvenile; Riker's Island, New York.

This work reflects the ascendance of Mexicans in the metropolitan
New York area, displacing Hispanics of Puerto Rican and Dominican
ancestry.

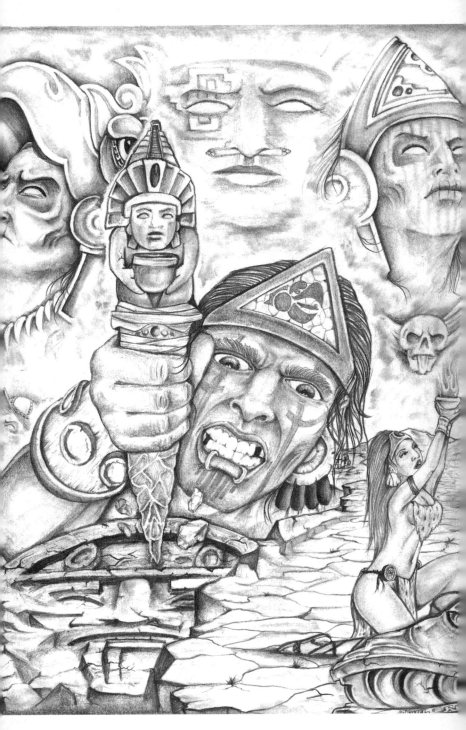

Latino male juvenile, age 18; gang-related violence; Los Angeles, California.

First arrested for gang and drug-related offenses.

Michael Orozco; Pelican Bay State Prison, California.

Michael began to contribute to *The Beat Within* when he was first arrested as a teenager.

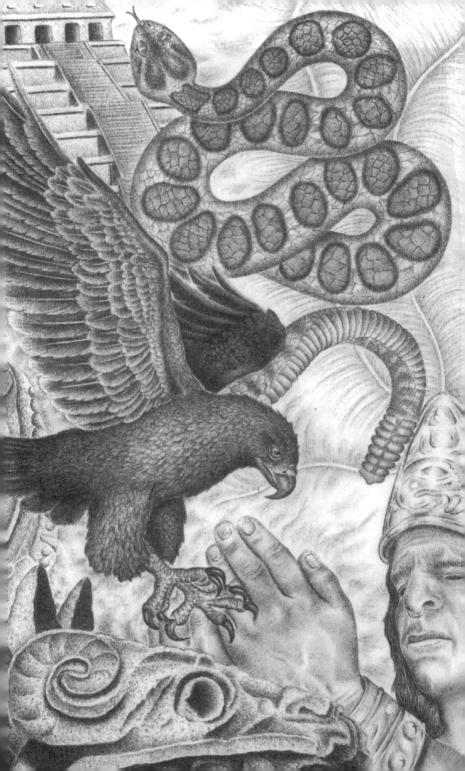

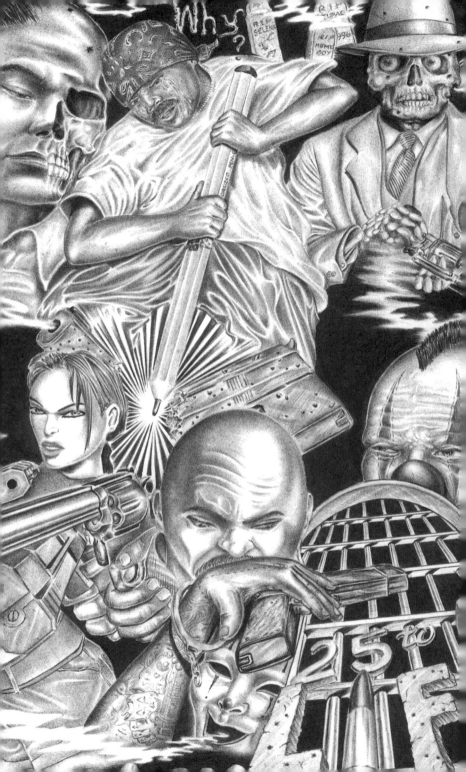

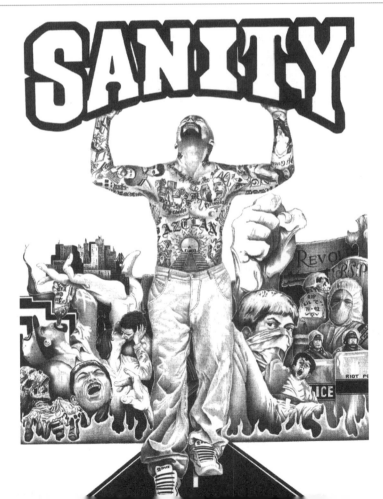

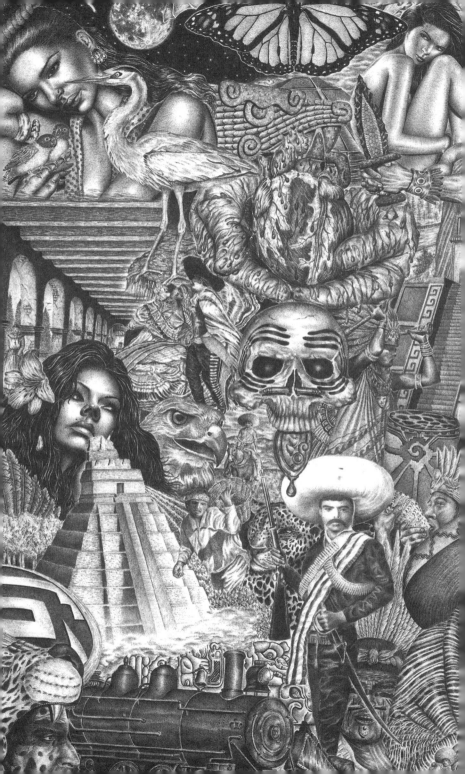

Latino male juvenile; gang-related violence; Los Angeles, California.

Now 20, this young man has been in the criminal justice system most of his youth. His work advances the political idea of a "Greater Mexico," the notion that it is Mexico's destiny to reoccupy all the territories that once comprised New Spain.

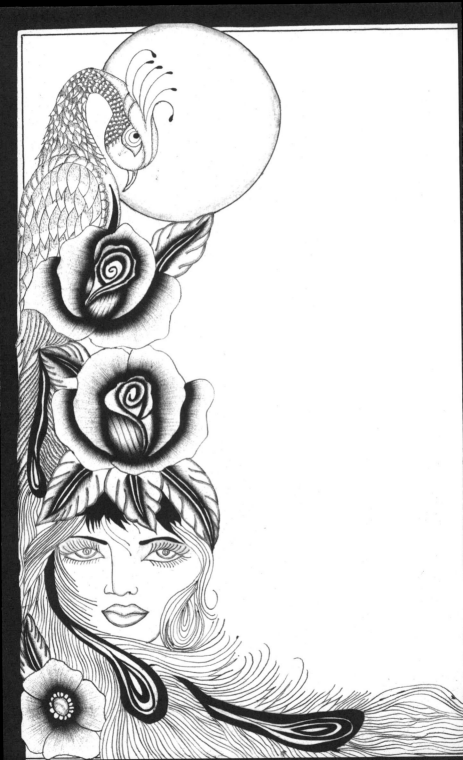

OPPOSITE PAGE:
Mervyn Wool.

First arrested at the age of 15, when he could hardly speak English. Now 24-years-old, Mervyn is no longer involved in gangs, and works for The Beat Within as a public speaker, peer mentor and writer.

NEXT PAGE:
Hispanic male juvenile, age 16; Texas.

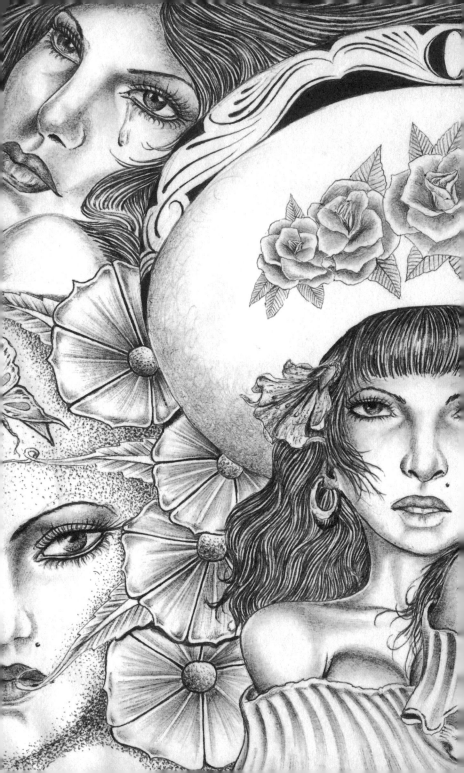

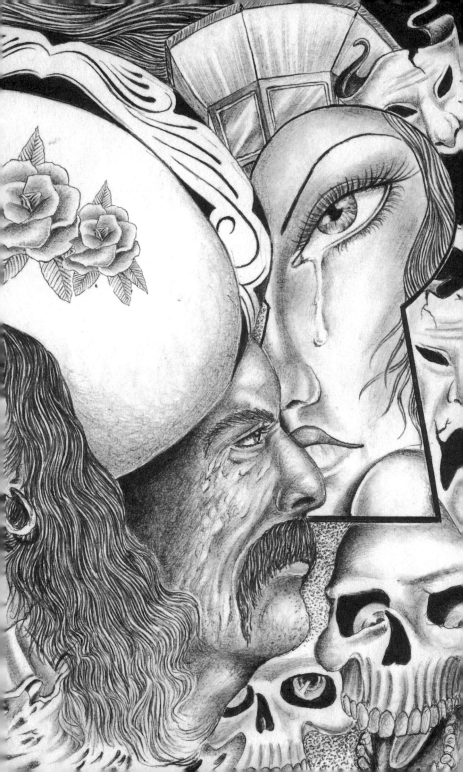

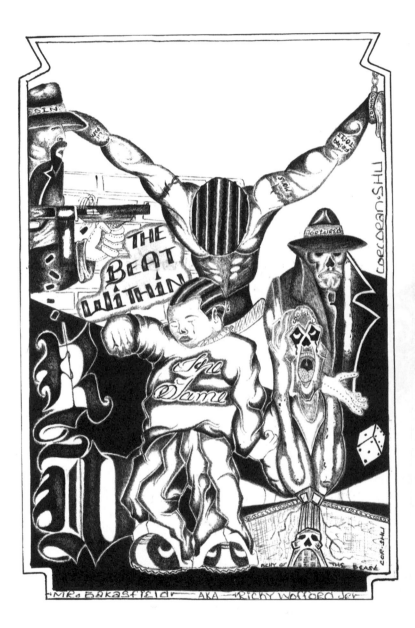

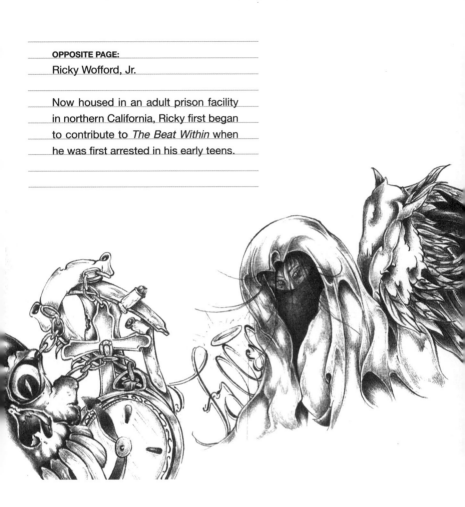

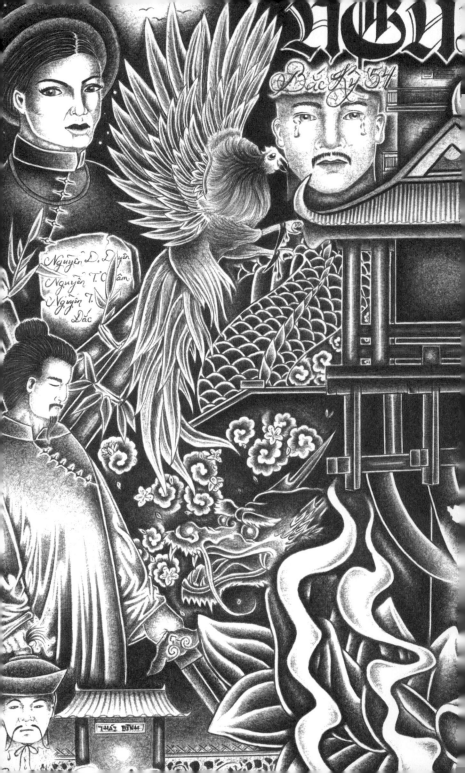

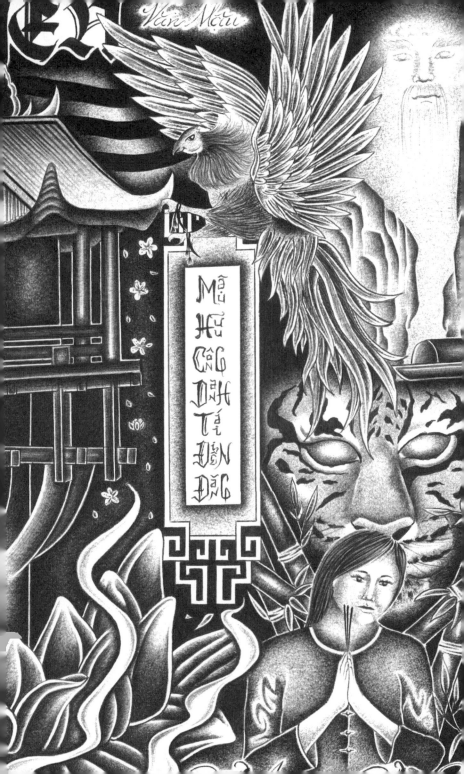

Hispanic male juvenile.

Now an adult, this young man began to contribute to *The Beat Within* soon after he was arrested as a teenager; his artistic work is also part of a prison program to raise awareness of health issues among inmates.

Nguyen Dat.

Currently in the Corcoran State Prison in California, Nguyen first began contributing to *The Beat Within* as a juvenile offender.

Start Learning to fight the reality of hepatitis-C in Prison

All photographs courtesy of Joseph Rodriguez, as previously seen in *Juvenile* (powerHouse Books, 2004). All photographs © Joseph Rodriguez.

Joseph Rodriguez's photographs have appeared in such publications as *The New York Times Magazine*, *Esquire*, *National Geographic* and *Newsweek*. He has received awards and grants from numerous foundations, including the National Endowment for the Arts and the Rockefeller Foundation. For more information, visit www.josephrodriguez.com.

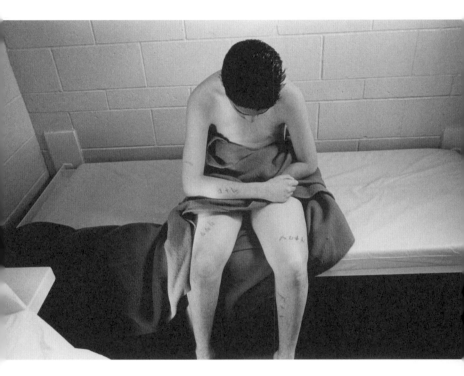

Self-mutilation. This 15-year-old cut himself, engraving various symbols and letters into his own flesh. He was declared 'high-risk' but after an evaluation determined that he wasn't suicidal, he was placed in B-6, a lower security unit. He also practices Satanism. San Jose Juvenile Hall. San Jose, California, 1999.

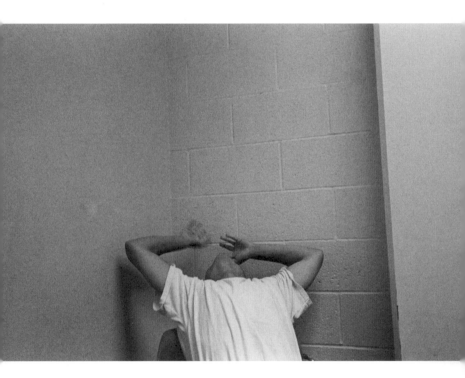

Jose, 17-years-old. He was arrested for violating probation; he was caught stealing beer from a convenience store. He is currently on medication to combat depression. His public defender, Christa Gannon, believed he had the potential to improve himself. She had proposed the courts to enroll him in a special school for "at risk" youth, called The Foundry. Here he stresses about facing the judge, worried about his future. San Jose Juvenile Hall. San Jose, California, 1999.

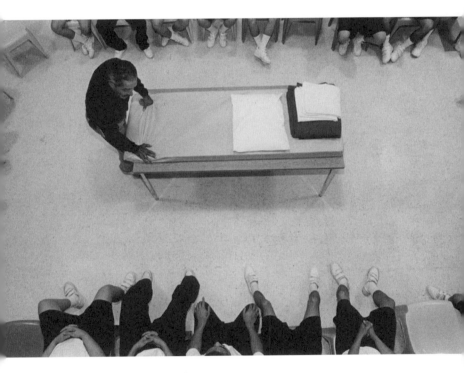

Sullivan is a counselor. He is responsible for showing these young men how to be compassionate and disciplined using military techniques. He instills in them a work ethic, how to start each day by organizing their space and making their beds. He tells them, "I'm your daddy right now," and takes it upon himself to teach these minors to be men. The facility houses many different juveniles but they have surprisingly similar backgrounds. Many belong to opposing gangs. The facility, though clean and orderly, is a tight space. Daily life inside consists of a rigorous routine and strict guidelines for the minors. San Jose Juvenile Hall. San Jose, California, 1999.

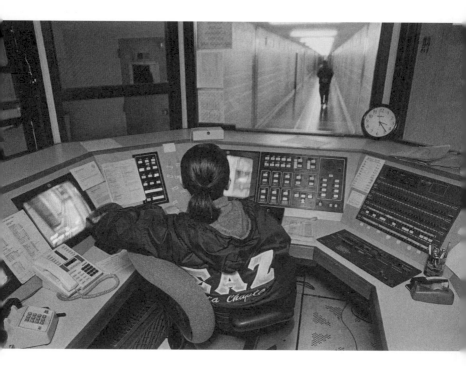

Security Command Center at Santa Clara County Juvenile Hall, San Jose, California, 1999.

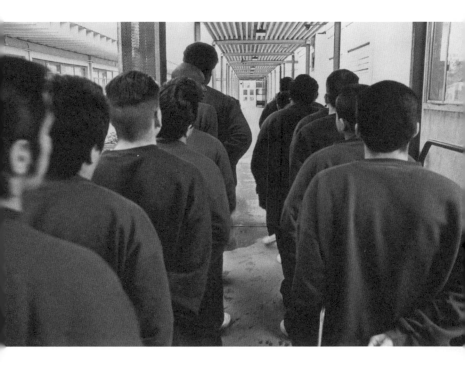

Santa Clara County Juvenile Hall, San Jose, California. The boy's Juvenile Hall unit lines up for school.

REVELING IN THE BEAT WITHIN

JEFF ADACHI

"Our expressive powers were strong and vibrant. If this could be nurtured, if the language skills could be developed on top of this, we could learn to break through any communication barrier. We needed to obtain victories in language, built on an infrastructure of self-worth."

Luis J. Rodriguez
Excerpt from *La Vida Loca: Gang Days in L.A.*

There is a voice within each of us that counsels our conscience, consoles our spirit, and advises our understanding of our place in the world. For many young people, the significance of this voice is drowned out by the resounding external dissonance of poverty, poor education and chronic abuse. Once children believe that their voices are powerless against these invisible forces, they lose confidence in expressing themselves outwardly, relegating their internal dialogue to silence.

In a complicated world of overwhelming and often conflicting messages, we must resist the outdated notion that "children are to be seen and not heard," and instead trust youths to listen to their inner voices and express themselves. This is particularly important for detained or incarcerated youth in California, and elsewhere, who are often vilified by the mainstream media. For too long the voices of these young people were rarely heard. That was until The Beat Within provided them with "an infrastructure of self-worth" and encouraged them to speak, write and draw.

The Beat Within started when David Inocencio, an acclaimed photographer who was then interning with the juvenile division of the Public Defender's office, proposed a revolutionary idea: to provide youth empowerment writing classes in juvenile detention facilities. Now in its twelfth year, The Beat Within, with the support of its dedicated staff and the Pacific News Service, offers weekly writing workshops where incarcerated youth are taught to honor their own voice and the voices of their peers. The workshops are the first formal writing instruction classes that many of these youths will receive. Those who face the additional hurdle of illiteracy are encouraged to recite their thoughts to facilitators who take time to transcribe their work. Their work is then edited for publication, and is distributed to thousands of *The Beat Within* readers each week.

There is no set style or singular form characterizing the art that is facilitated by The Beat. Each piece is uniquely styled to the internal rhythms of each child. Whether these rhythms inspire poetry, prose, or illustrations the power of a resurrected inner voice cannot be denied, like true Renaissance poets. *The Beat Within* contributors speak of the hurt they have inflicted and the hurt that has been inflicted on them. Their work at once exposes the truth of the world they grew up in and reflects on the reality of their current existence.

The words that appear in print are as raw as the emotions from which they were forged. For these young writers and drawers, publication fosters a sense of liberation—not only from the bars and razor wire of the juvenile justice halls, but from the trappings of their circumstances. Youth recognize the power of their individual voices and see the impact that their collective song can have on others. Through communication a sense of community is born among *The Beat* contributors and facilitators. The strength of this community transcends the boundaries of the detention centers and lasts well beyond release.

When we suffocate our inner voice, we stifle our ability to self-reflect. Therefore, peer mentors encourage the therapeutic properties of writing. They critically read each piece of work and facilitate the progression of expression from the initial venting of anger at "the system," to owning responsibility for one's choices, and finally to seeing oneself as part of the larger society in which we all function. Writers are challenged to think as teachers as they reflect on their pasts and look ahead to their futures.

To many in society, the personal plights of incarcerated youth remain as abstract as the motivations for the actions that led them into the system. Thanks to The Beat Within, we now have a window and a line of communication into a world that few can imagine.

But what will we hear when we listen to our youth speak? We will hear the beating of our own hearts as we are confronted by the demons of violence, drug use, abandonment and abuse that *Beat* contributors have battled. We will hear familiar ruminations over nascent dreams and lamented dreams deferred. However, what will ultimately dominate our senses and resonate in our core, are the exaltations of unbridled youthful hope communicated through vibrant and powerful expression.

The success of The Beat Within is due to the simple fact that it provides things that few of these youngsters have known before: a sense of self-worth, a powerful voice, and the feeling of belonging. As youth begin to trust their inner voice, they begin to believe in themselves again. In the end, they learn that while their bodies may be temporarily imprisoned, they can still write their souls to freedom. It is the "infrastructure of self-worth" that allows us to truly realize and appreciate the real stories and humanity of incarcerated youth.

Jeff Adachi is the elected Public Defender of the City and County of San Francisco. His office provides legal representation, social work, and advocacy services to over 1,000 youth each year. He is a leader in juvenile justice reform efforts and an advocate of alternative to incarceration programs.